# GETTING STARTED

Manga is among the most popular styles of cartoon art in the world. This book gives you the tools you need to draw the popular character types you love. With these techniques, you'll learn to draw the features of the face, various angles of the head, basic poses, and clothes, too. Sketching and shading manga characters is a great way to be creative.

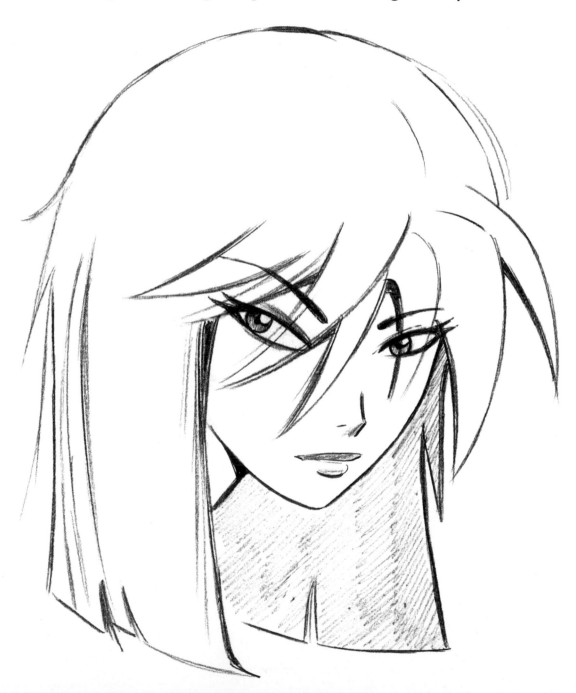

# THE BASIC HEAD

Each character is different and yet, manga characters share a basic, stylistic look. This chapter will give you the essentials for creating that well-known manga look for any character you desire. We'll focus on the eyes, and on the basic shape of the head at a variety of angles.

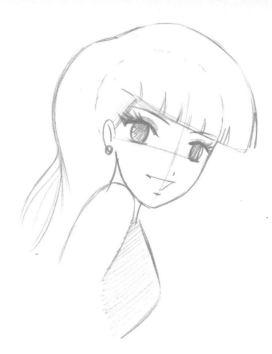

Add shading to the upper eyelids.

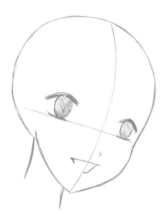

Draw upper and lower eyelids to bracket the large eyeballs.

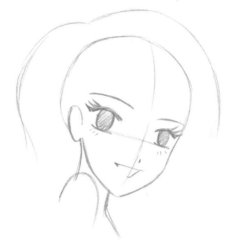

Draw thin, arching eyebrows and long eyelashes. Keep the nose and mouth light.

## MANGA EYES

Some people finish one eye, and then begin the other eye, and finish that one, too. But going about it that way may make it more difficult to get both eyes to look the same. Instead, I recommend going back and forth, from one eye to the other until both are complete.

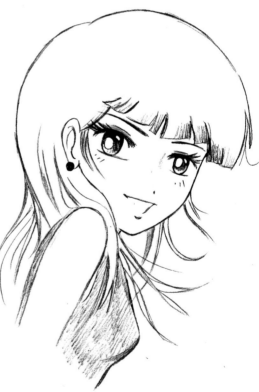

Generally speaking, the bigger the shines of the eyes are, the younger the character looks.

# HOW TO SHADE THE EYES

The eye has three tones: black, gray, and white. The more white areas ("eye shines") you draw, the more glittering the eyes will be.

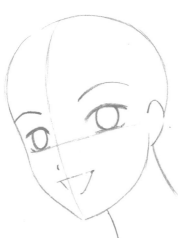

Curved eyebrows work well with a smiling expression.

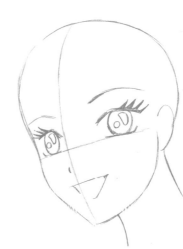

The tip of the nose is drawn off of the Center Guideline.

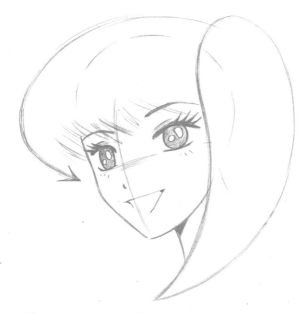

Use a sweeping line to curve around the head and create the line of the hairstyle.

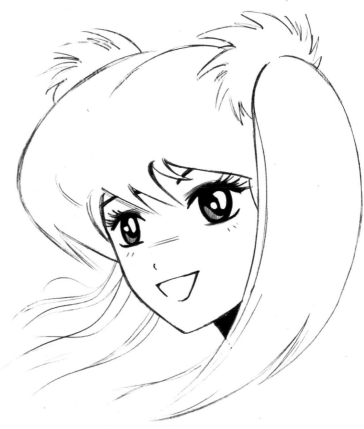

To add a creative touch, draw some inventive hair-ties for the pigtails.

# PRETTY EYES - SLENDER

The largest manga eyes appear on young characters. Teens have medium-large eyes. On adult females, such as this beautiful Japanese princess, the size of the eye is reduced but the style and shape makes her glamorous.

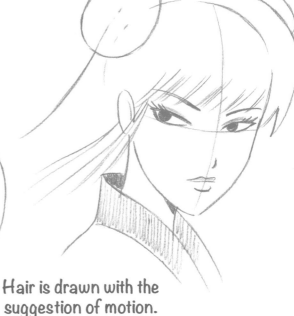

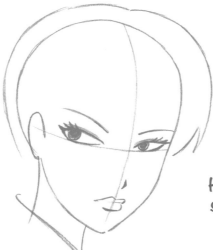

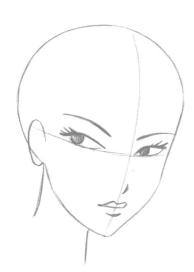

Hair is drawn with the suggestion of motion.

Indicate an outline of the hairstyle.

The eyebrows dip toward the bridge of the nose.

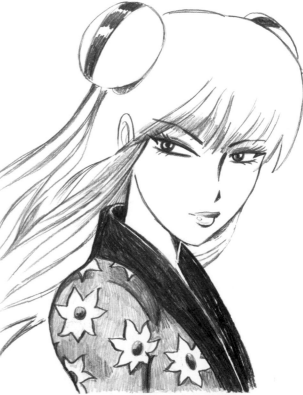

Though the eyeballs are small, they still have "shines" in them, which make them pretty.

# MALE EYES

Naturally, male eyes are drawn differently from female eyes. But exactly how? And which aspects of the eyes are emphasized in order to create the difference? Let's take a look.

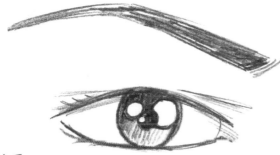

## MALE

- Thick eyebrow
- A few small eyelashes are okay
- Small eyeball with a few flecks of white highlights

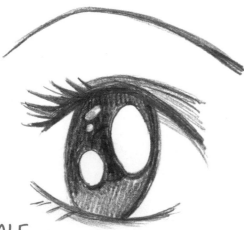

## FEMALE

- Larger eyeballs with bigger highlights
- Thin eyebrows
- Prominent eyelashes

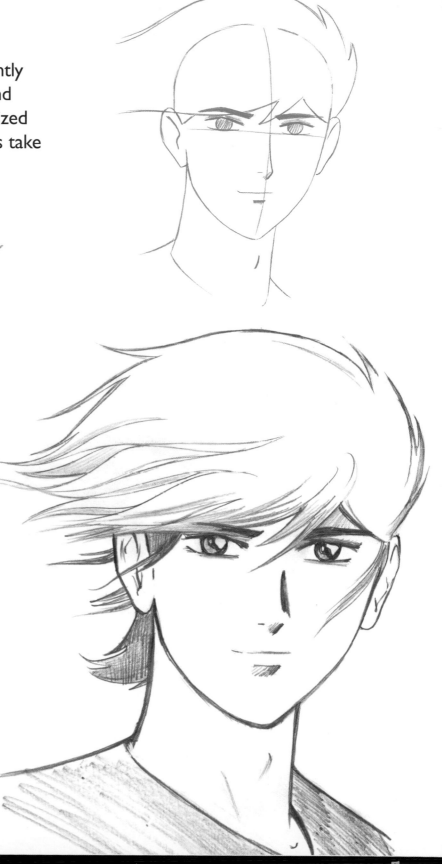

# MALE EYES - SOFT STYLE

Young teen boys are typically drawn as energetic characters with large eyes. As the character gets older his face becomes elongated, and the eyes become smaller and more horizontal in shape. Notice that they take up less room as a proportion of the face.

Note how the upper eyelid presses down on the eyeball.

The lower eyelid rises to meet the upper eyelid.

There is a subtle crease above the eye.

# THE EYE IN PROFILE

When viewed from the side, the eye takes on a different shape. The obvious change is that the length of the eye appears to be reduced. However, another equally important element is often overlooked by many beginners: the pupil itself changes from a circle to a short, vertical line.

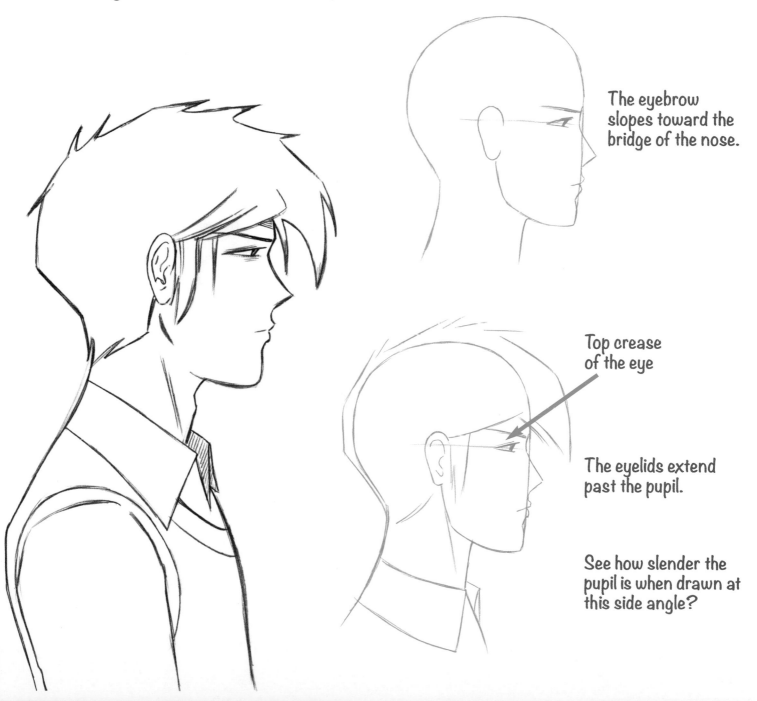

The eyebrow slopes toward the bridge of the nose.

Top crease of the eye

The eyelids extend past the pupil.

See how slender the pupil is when drawn at this side angle?

# DRAWING THE BODY

Now we'll cover a number of popular poses, which you can use to give your characters a natural look. These suggestions are the building blocks for poses. You can make up different arm positions, or change the placement of the legs. Perhaps you'd like to tilt the head a touch, or raise or lower a shoulder, etc. Feel free to experiment. That's all part of the drawing process.

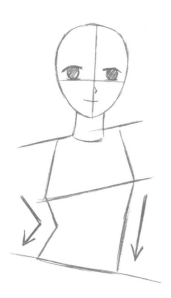

One side of torso bends; the other is straight.

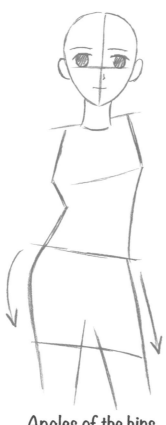

Angles of the hips

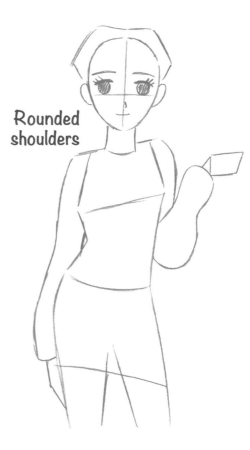

Rounded shoulders

# BASIC STANDING POSE

When a person stands in a relaxed pose, they usually lean slightly to the left, or slightly to the right. If they lean left (page left), then their shoulders dip to the left, too. If they lean right (page right), then their shoulders dip to the right. Let's see how this works in practice.

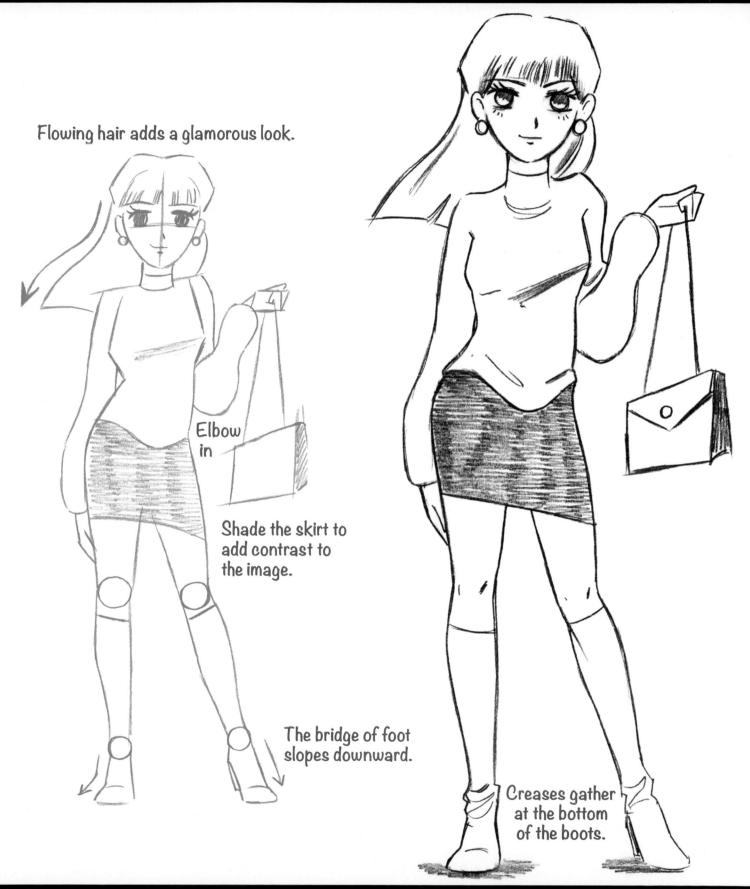

Flowing hair adds a glamorous look.

Elbow in

Shade the skirt to add contrast to the image.

The bridge of foot slopes downward.

Creases gather at the bottom of the boots.

# SCHOOLBOY (TEENAGE POSTURE)

At one time or another, everyone's mom has told them to stand up straight. So you do it—until you leave the house, and then you slouch again! But we still need to be able to draw a slumping, funny teen posture for our school-age characters. Let's see how it's done.

Shoulders slope.

The arms are back, but the far shoulder still shows.

Use long, sweeping lines that flow down the length of the figure.

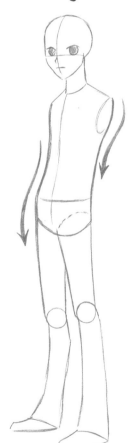

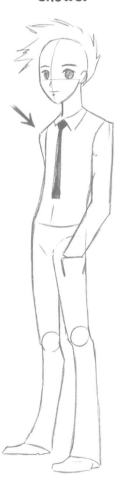

The knees are locked.

The hips are slightly out; the chest is slightly in.

The far side of the jacket is shaded to show depth.

# VERSATILE POSES

The "hands on the hips" pose is a popular pose that's used to show a variety of attitudes. By simply adjusting the character's expression, the pose can reflect cheerfulness, impatience, skepticism, or puzzlement.

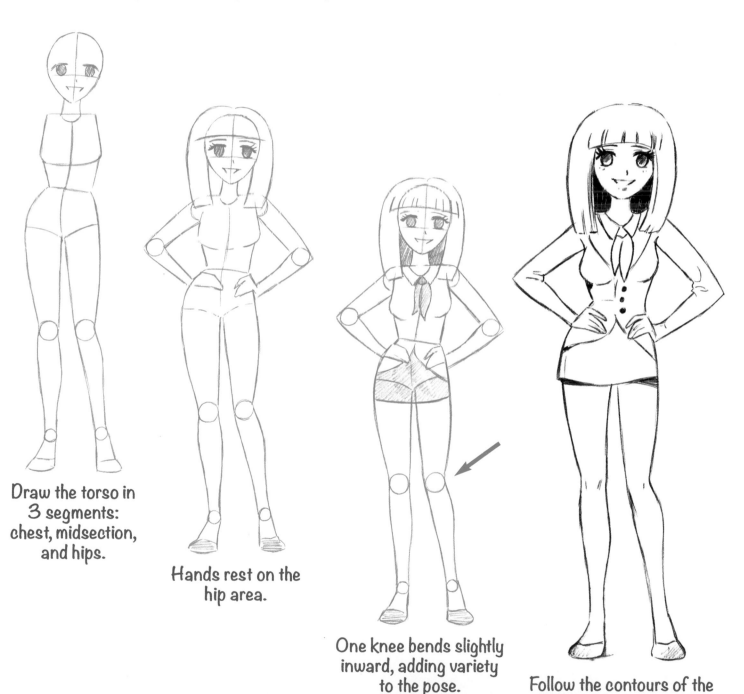

Draw the torso in 3 segments: chest, midsection, and hips.

Hands rest on the hip area.

One knee bends slightly inward, adding variety to the pose.

Follow the contours of the body to draw the outfit.

# HIGH SCHOOL GYMNAST (SITTING POSE)

When a figure sits, new body dynamics are set in motion. Primarily, the principles of compression and overlap come into play. Let's see how they work.

To have an upright posture, the back must arch.

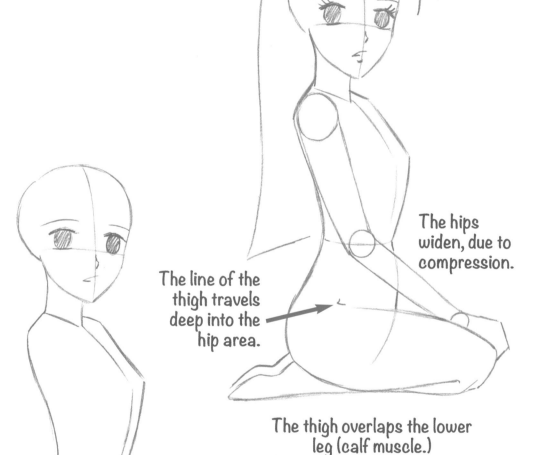

The line of the thigh travels deep into the hip area.

The hips widen, due to compression.

The thigh overlaps the lower leg (calf muscle.)

Feet extend past hip area.

The knees are squared off when the figure is kneeling.

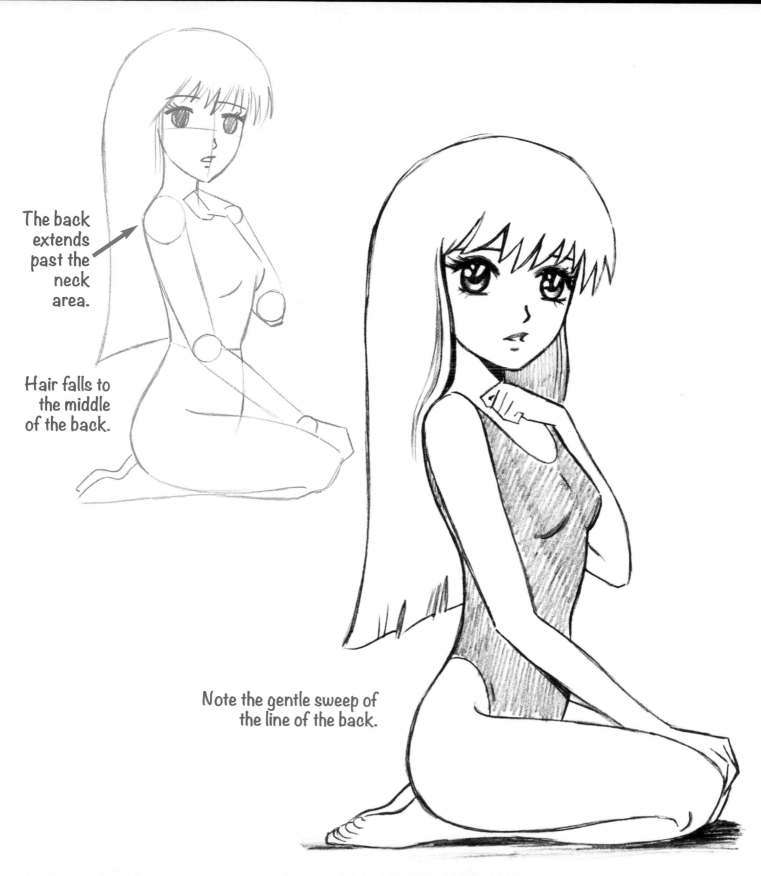

The back extends past the neck area.

Hair falls to the middle of the back.

Note the gentle sweep of the line of the back.

# HAVING FUN (PLAYFUL POSES)

Here's a classic manga pose, which you see in a lot of one-shots (that means single illustrations, as opposed to sequential panels.) This pose is symmetrical, in other words, the arms and legs on the left side of the body are in the same position as the arms and legs on the right side of the body. When drawing a symmetrical pose, use care so that the left side and right side match up. You don't want the left hand, for example, to appear higher than the right hand.

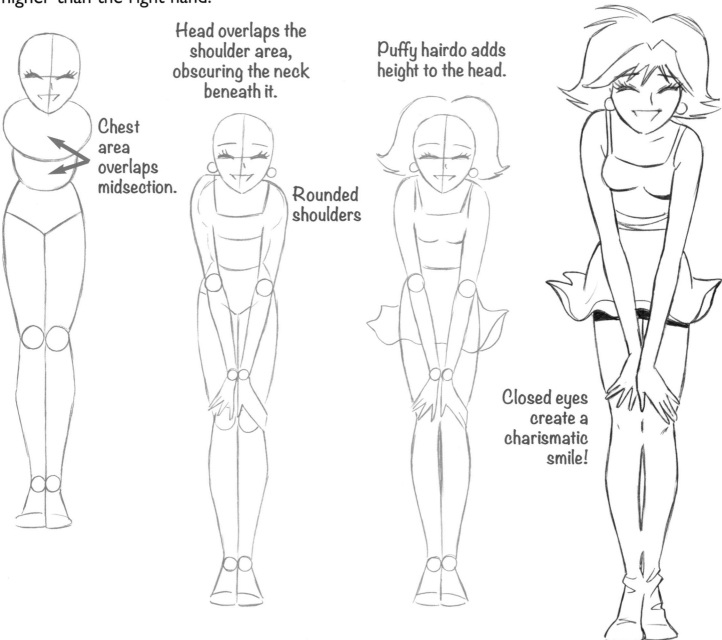

Head overlaps the shoulder area, obscuring the neck beneath it.

Chest area overlaps midsection.

Rounded shoulders

Puffy hairdo adds height to the head.

Closed eyes create a charismatic smile!

# HEROIC POSE (EXAGGERATED PERSPECTIVE)

Exaggerated perspective is used to increase the impact of a pose. The effect works because of the angle: the outstretched limb appears to be coming toward you, almost in 3D. To draw an effective pose with exaggerated perspective, first turn the body to the side, so that it no longer appears to be in a front view. From the first step you can see that the body has been angled so the shoulder faces the viewer (you).

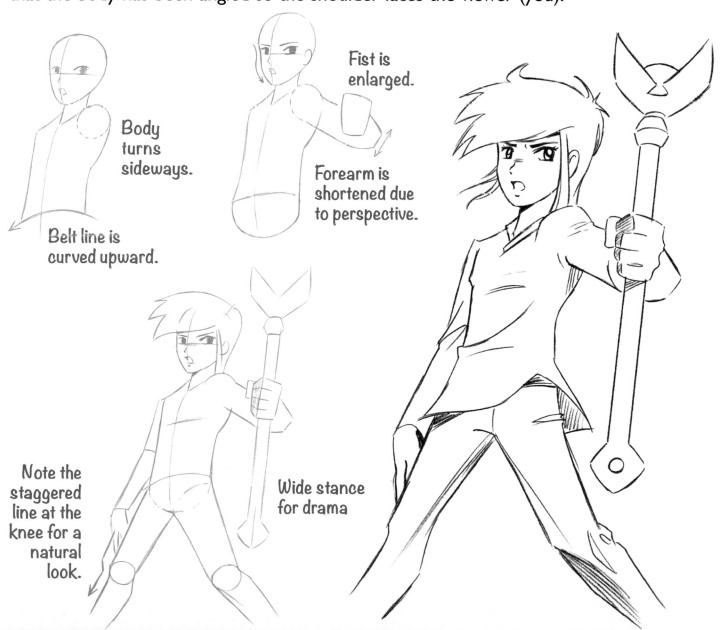

Body turns sideways.

Belt line is curved upward.

Fist is enlarged.

Forearm is shortened due to perspective.

Note the staggered line at the knee for a natural look.

Wide stance for drama

# EMOTIONS & EXPRESSIONS

One of the things that makes manga so popular is the sheer range of emotions you can get from the characters. The trick is to use subtle features to show bold emotions.

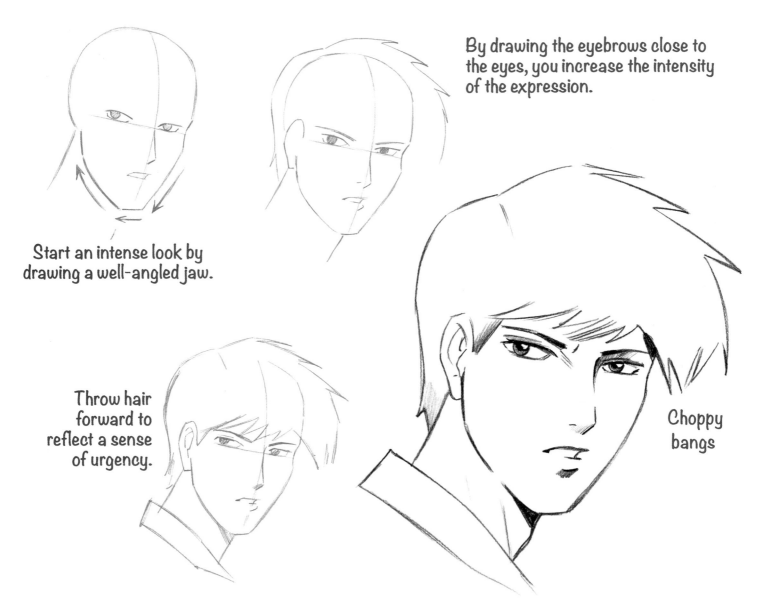

By drawing the eyebrows close to the eyes, you increase the intensity of the expression.

Start an intense look by drawing a well-angled jaw.

Throw hair forward to reflect a sense of urgency.

Choppy bangs

# THE CLASSIC "INTENSE" BOY

Manga has many good-guy characters. These characters are extremely loyal to their friends, and often display courage to stand up for them.

# LONELY NEKO

A "Neko" is a cat-girl character. They're popular in all manga genres. Let's begin by creating an "alone" moment, which often reflects a romantic problem.

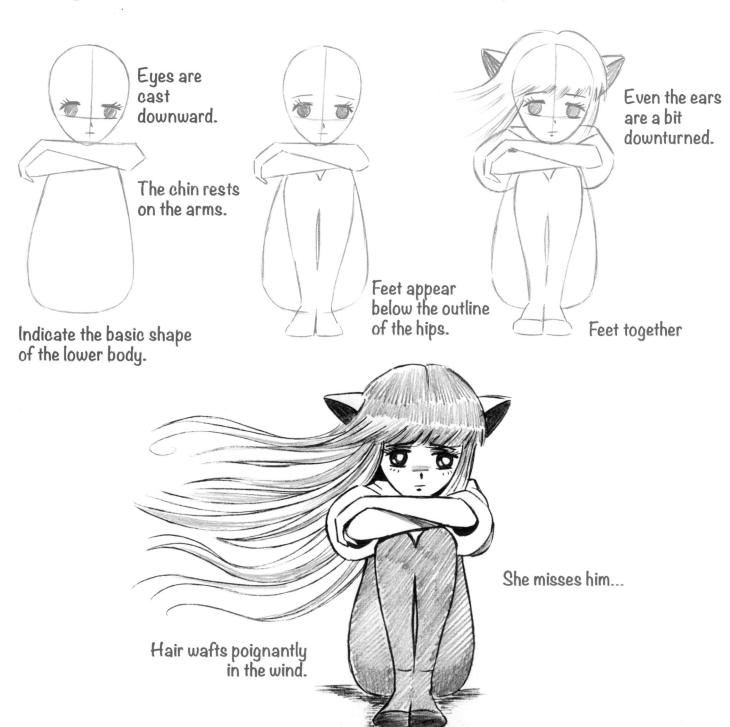

Eyes are cast downward.

The chin rests on the arms.

Indicate the basic shape of the lower body.

Feet appear below the outline of the hips.

Even the ears are a bit downturned.

Feet together

Hair wafts poignantly in the wind.

She misses him...

# HMMPH! (SURPRISE)

In manga, the "surprised" look is used in a lot of humorous situations. It can give the character a disarming charm. This expression is created with just two details: wide eyes and a small mouth. Keep it that simple. Her little pet also has a surprised expression!

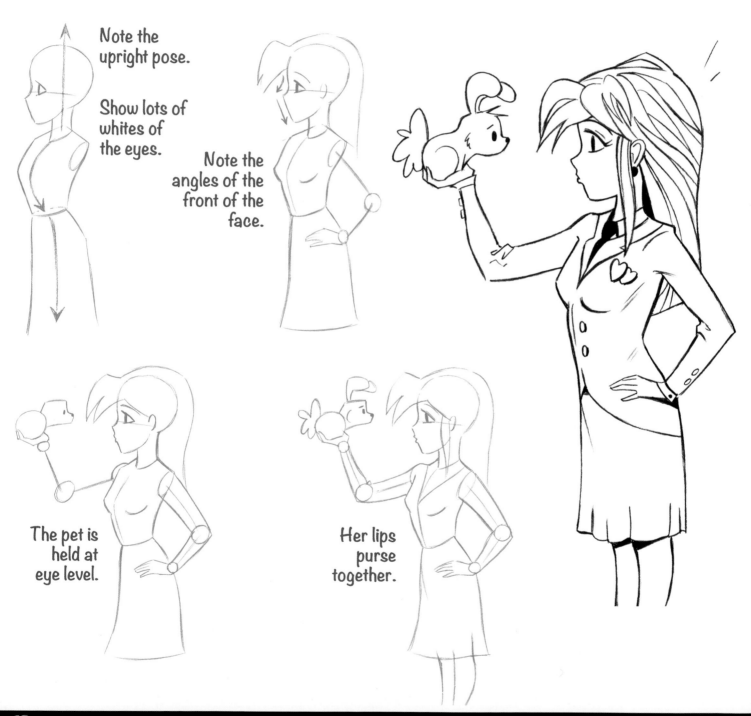

Note the upright pose.

Show lots of whites of the eyes.

Note the angles of the front of the face.

The pet is held at eye level.

Her lips purse together.

# FRIGHTENED & PROTECTIVE

Manga friends are lifelong buddies. Whether it's an enchanted doll looking out for her owner, or a school age cat-girl protecting her fluffy buddy, the bonds of friendship are unbreakable. Let's see how we can infuse that spirit into two such characters.

Big eyes, Small mouth

Eyelids rise off of the eyes, for a frightened expression.

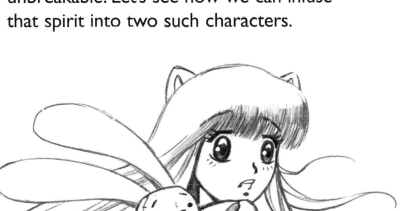

Her body faces left (page left), shielding the bunny doll from whatever evil awaits them.

Arm and shoulder wrap tightly around the bunny doll.

The doll gestures frantically, trying to warn the girl.

# GOODBYE TO AN OLD FRIEND (GRIEF)

When it comes to creating emotions, the tilt of the head is quite telling. A downward tilt strengthens sad expressions, while an upward tilt strengthens hopeful emotions.

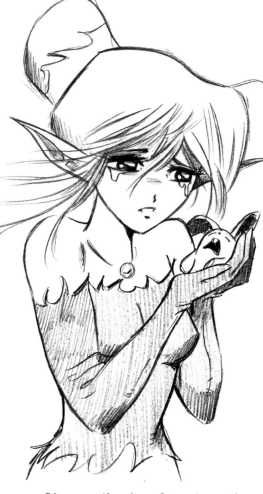

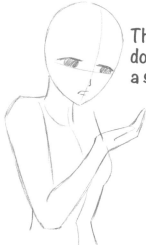

The upper eyelids push down on the eyes, creating a sad expression.

Her hair cascades down... she's brokenhearted.

She cradles her friend gently with open hands.

Both shoulders are raised, as the character pulls inward (introspection.)

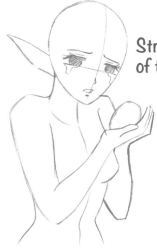

Streams of tears

Head down; sad

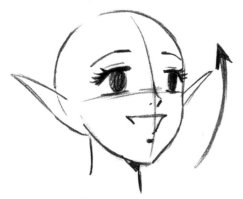

Head up; hopeful

# SO COOL

"Cool" is an attitude. It's having a confident look for no reason in particular. Every breeze that blows past ruffles this guy's hair and flaps his clothing in a cool way. That look in his eyes says that he knows he's cool. That's what's so cool about him.

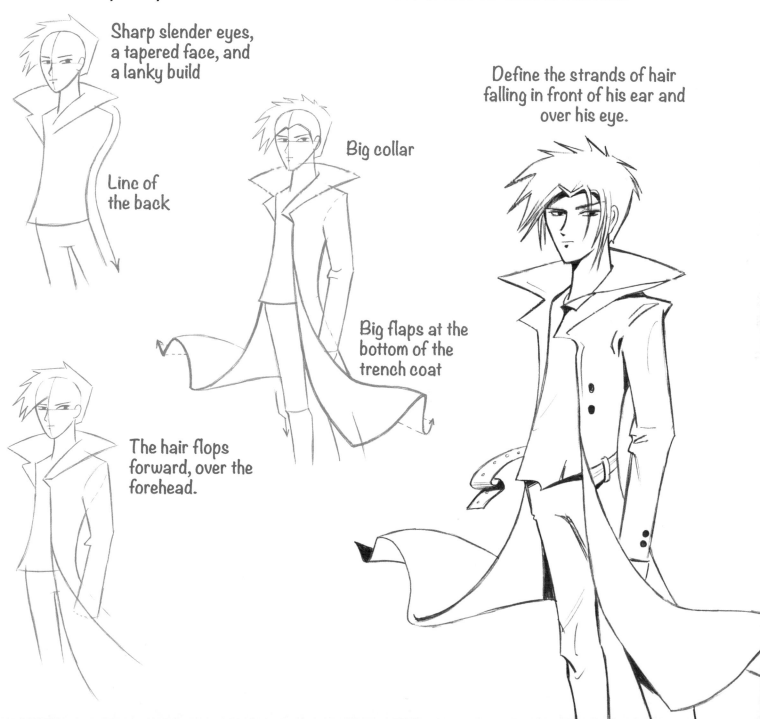

Sharp slender eyes, a tapered face, and a lanky build

Line of the back

Define the strands of hair falling in front of his ear and over his eye.

Big collar

Big flaps at the bottom of the trench coat

The hair flops forward, over the forehead.

# HAIRSTYLES: THE FINISHING TOUCH

Manga characters are sometimes restricted in their attire because they so often wear school uniforms. Therefore, a character's personal style and individuality are largely expressed through the hairstyle. Let's look at some popular choices.

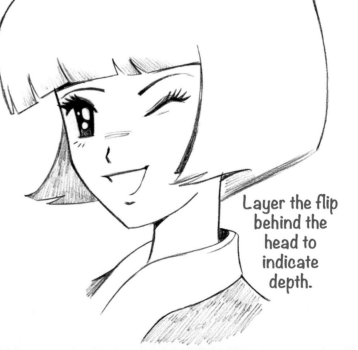

Bangs fall just above the eyebrows.

Note the slope of the hair at the back of the neck.

Basic head construction

# SHORT WITH BANGS

This haircut is a cute and simple look. It's a great way to get started fashioning trendy styles for your characters.

Layer the flip behind the head to indicate depth.

# LONG HAIR

Long hair can be styled in many ways. But no matter how you fashion it, you can always add a little more bounce by suggesting motion. Drawing long, flowing lines adds life to a hairdo.

Start by laying down the foundation of the head and body.

Firm up the construction.

Hair adds size to the front and the back of the head.

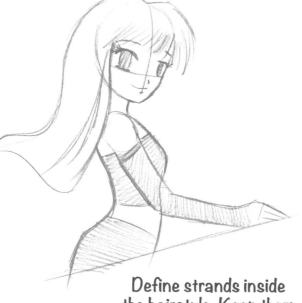

Define strands inside the hairstyle. Keep them clear and flowing.

# LAYERED HAIR

The multi-layered hairdo is a super-popular look in manga. I recommend first drawing the overall outline of the hair to establish its size and shape. Next, go in and detail the individual layers. The layers aren't drawn at random. They have direction. They either flow to the left, or to the right.

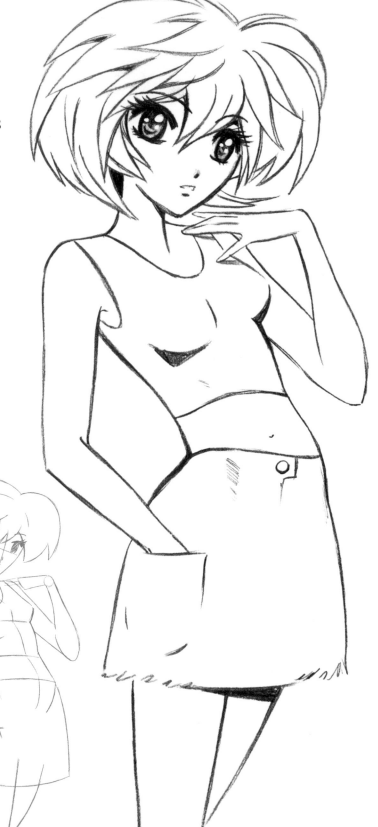

Basic construction of the head and torso

The hair parts in the middle.

Give this cut extra size.

Back curves in.

Hair flops over the forehead in a casual manner.

# BRUSHED FORWARD

This simple, yet effective technique of brushing the hair forward creates the distinctive look of manga—repeated, pointy wisps. These forward-leaning wisps can be greatly exaggerated to ridiculous proportions, as we've all seen on various TV shows. Or they can be more subtly applied, such as the example on this page.

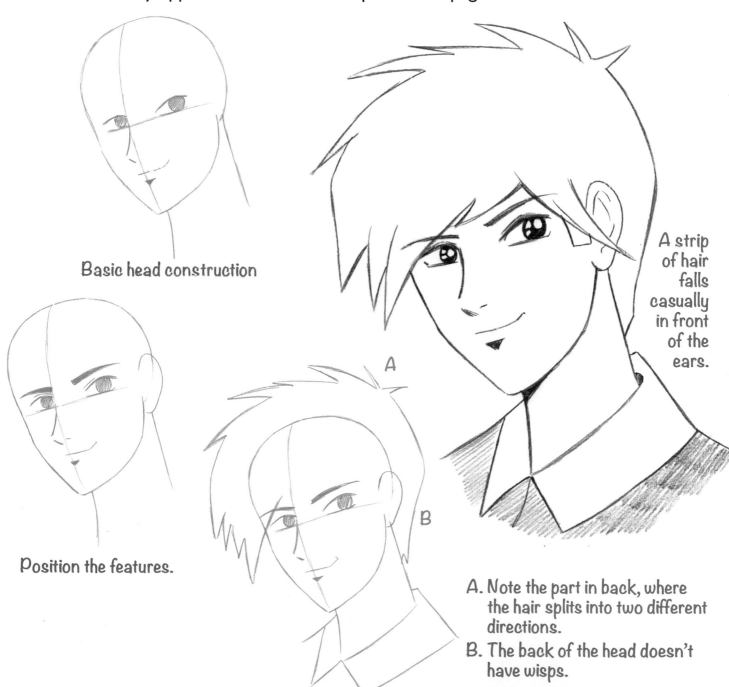

Basic head construction

Position the features.

A strip of hair falls casually in front of the ears.

A

B

A. Note the part in back, where the hair splits into two different directions.

B. The back of the head doesn't have wisps.

# HAIR FALLING IN FRONT OF THE EARS

Here's a really great technique for you. It's seen on many of the most popular manga characters, especially glamorous ones. It features super-long strands of hair that cascade over, and in front of, the ears. For this to look good, it requires a flowing line, so that the hair appears to be lifted by a gentle breeze.

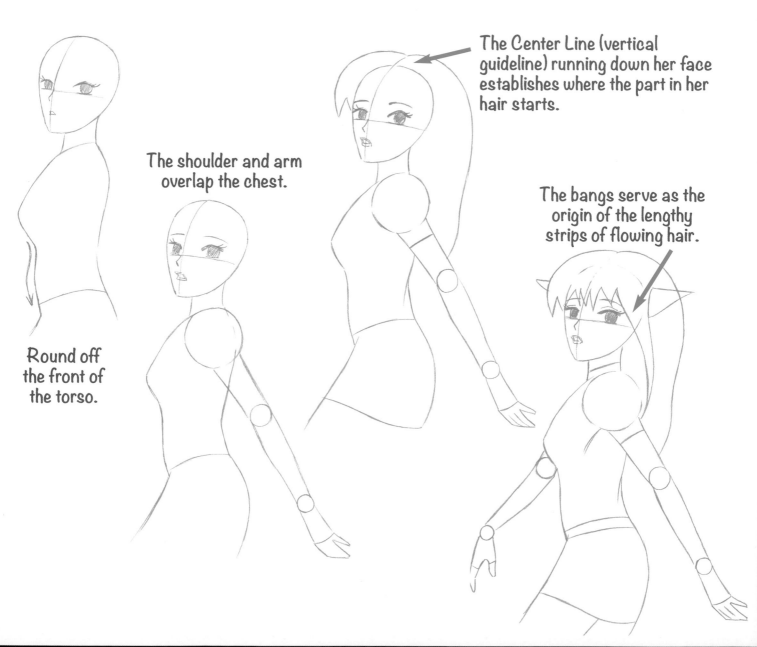

The Center Line (vertical guideline) running down her face establishes where the part in her hair starts.

The shoulder and arm overlap the chest.

The bangs serve as the origin of the lengthy strips of flowing hair.

Round off the front of the torso.

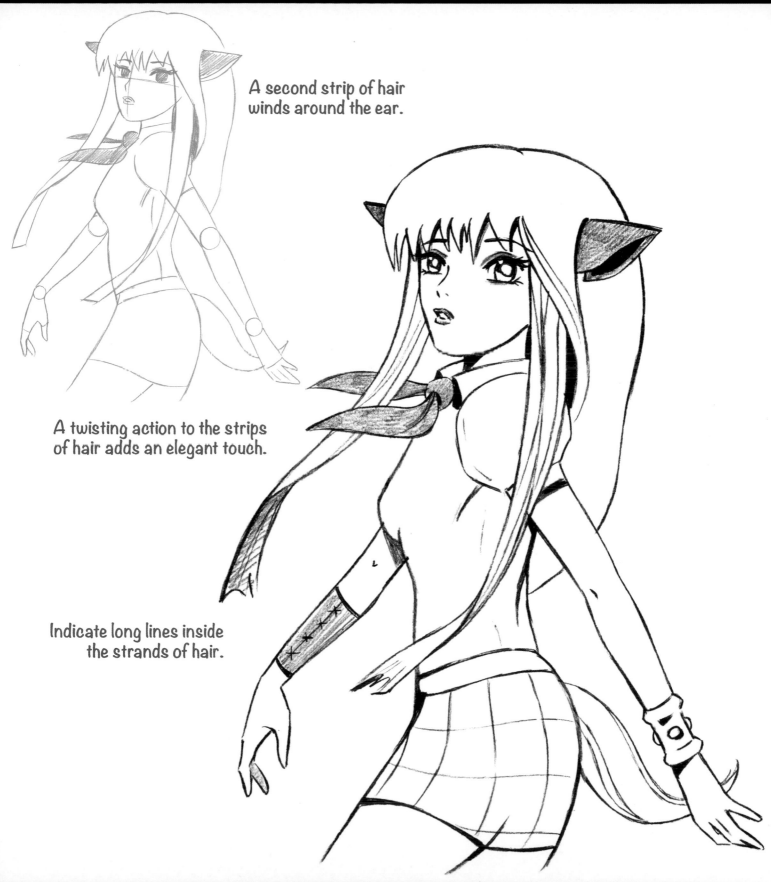

A second strip of hair winds around the ear.

A twisting action to the strips of hair adds an elegant touch.

Indicate long lines inside the strands of hair.

# HEADBAND

The angle of the face shifts at the cheekbone.

The addition of a headband adds a touch of variety. Headbands can be drawn with a pattern, or finished with a simple color. They are especially useful when you have a character with a traditional haircut, and you want to liven things up a bit. The headband is drawn at the top of the head, and wraps around the back of the ears.

The hair is higher at the rear of the head, and slopes downward toward the bangs.

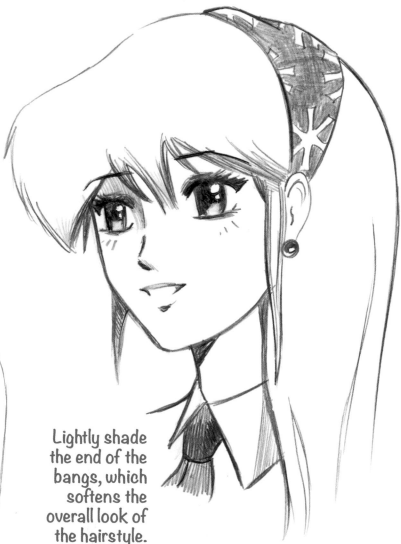

Simplify the bangs into a few groups of strands pointed below the eyebrows.

Lightly shade the end of the bangs, which softens the overall look of the hairstyle.

# CAP & EAR MUFFS (BRRRRRR!)

Caps and hats are drawn high on the head to indicate the size of the hairdo underneath. Our pretty, winter warrior is having second thoughts about going up the slopes for a ninth run down the mountain. The earmuffs and scarf are also important, and together create a fun, accessorized look.

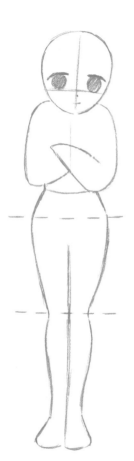

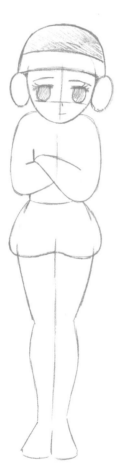

Add a textured trim to the hat.

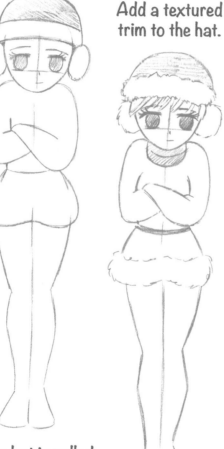

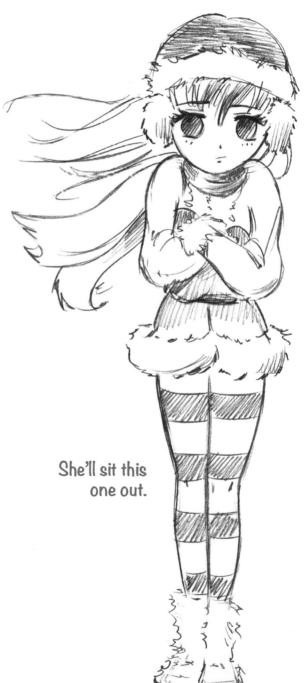

She'll sit this one out.

To maintain the symmetry of this pose, we "self-check" to be sure that the hips and knees are aligned at the same levels.

The hat is pulled down over two-thirds of the head. It doesn't simply rest on top.

The scarf completely hides the neck.

# CREATING CUTE SCENES

We've covered faces, poses, expressions, and hairstyles. Now let's take those elements and use them to draw some cute characters in casual moments.

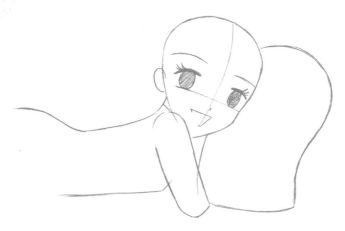

Her shoulder overlaps her face, and this body language assists us in creating a very sweet look.

The face is drawn inside the outline of the pillow.

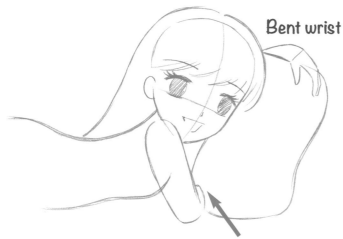

Bent wrist

A fold of clothing bunches at the elbow, where the arm goes underneath the pillow.

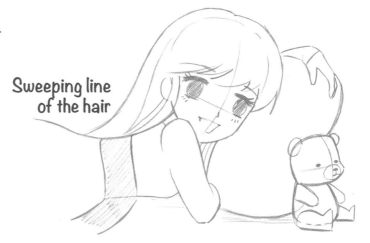

Sweeping line of the hair

Teddy has a plump bottom!

# STARTER SCENE – GIRL WITH TEDDY BEAR

There's something cozy about being under the covers with a teddy bear. To enhance the look, we've drawn a puffy pillow, and indicated a few of teddy's stitches.